Missouri Landscapes

DESIGNS FROM NATURE

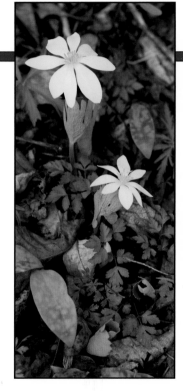

PHOTOGRAPHY BY KEVIN SINK

DESIGN BY LYNETTE UBEL

DESIGNS FROM NATURE PRESS,
ROELAND PARK, KANSAS

COVER PHOTO OF DOGWOOD, THE STATE TREE OF MISSOURI,
TAKEN AT LAKE OF THE OZARKS STATE PARK, CAMDEN COUNTY

Copyright of photographs and text: Kevin Sink, 1999
Designer: Lynette Ubel
Editor: Jane Cigard
Production: International Graphics, Scottsdale, AZ
Printed in Hong Kong
Published by Designs From Nature Press, a division of Designs From Nature™, LC
 4904 Mohawk Drive, Roeland Park, KS 66205-1541

 Special thanks to the following publishers and authors who granted permission for the
quoted material in the text:
 From *A Sand County Almanac: With Other Essays on Conservation from Round River* by
Aldo Leopold. Copyright 1949, 1953, 1966, renewed 1977, 1981 by Oxford University
Press, Inc. Used by permission of Oxford University Press, Inc.
 From *Ideas and Opinions* by Albert Einstein. Copyright 1994 by The Modern
Library/Random House. Used by permission of The Crown Publishing Group.
 From *Things Precious and Wild, A Book of Nature Quotations* by John K. Terres.
Copyright 1991. Used by permission of Fulcrum Publishing, Inc.
 From *The Power of Myth* by Joseph Campbell & Bill Moyers. Copyright 1988 by
Apostrophe S Productions, Inc. and Bill Moyers and Alfred Van der Marck Editions, Inc. for
itself and the estate of Joseph Campbell. Used by permission of Doubleday, a division of
Bantam Doubleday Dell Publishing Group, Inc.
 From the poem "The Third Thing", from *The Complete Poems of D.H. Lawrence* by D.H.
Lawrence, edited by V. de Sola Pinto & F.W. Roberts. Copyright 1964, 1971 by Angelo
Ravagli and C.M. Weekley, Executors of the Estate of Frieda Lawrence Ravagli. Used by per-
mission of Viking Penguin, a division of Penguin Putnam Inc.
 From the poem "In the Center of Your Soul", from *There are Men too Gentle to Live
Among Wolves* by James Kavanaugh. Copyright 1970, 1984. Used by permission of James
Kavanaugh and Steven Nash Publishing.
 From *Markings* by Dag Hammarskjold. Copyright 1964. Used by permission of Alfred A.
Knopf/Random House, Inc.

Publisher's Cataloging-in-Publication Data:
Sink, Kevin.
 Missouri landscapes : designs from nature / photography
 by Kevin Sink ; design by Lynette Ubel. — 1st ed.
 p. cm.
 Includes bibliographical references.
 Preassigned LCCN: 98-93186
 ISBN: 0-9664964-0-X
 ISBN: 0-9664964-1-8 (signed and numbered limited edition)

 1. Natural history—Missouri—Pictorial works.
 2. Missouri—Pictorial works. I. Title.

 QH105.M8S56 1998 917.78
 QBI98-820

Flora

Woodland

Pattern

Water

Light

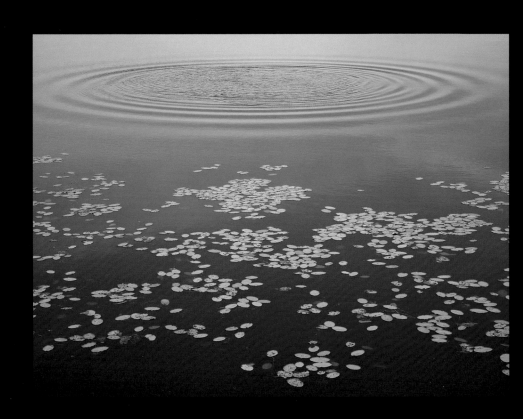

Kevin Sink

recreation, these preservation efforts have resulted in the conservation of extensive habitats unique to the natural history of Missouri. The success of outdoor recreation is intimately connected to the integrity of this network of plants, animals and viable habitats. Thanks to the Department of Conservation and the Department of Natural Resources, conservation of these habitats is state-of-the-art in Missouri. You would be hard-pressed to find a better conservation system anywhere else in America. Much remains to be done to protect natural communities and biodiversity, but Missouri is well on its way.

I would also like to thank the people of Missouri for supporting the Department of Conservation and the Department of Natural Resources. You are supporting government that works very well, benefits you, and is setting an example that other states should follow.

Many people in these agencies have helped me find places with unique natural features to photograph. Paul Nelson, Ken McCarty, and Tom Nagel of the Department of Natural Resources have been particularly patient and helpful with my inquiries. All of the following have not only been very helpful, but have been a real pleasure to work with: Laura Hendrickson and Cyndi Evans at Prairie State Park, Jodi Moulder of Ha Ha Tonka State Park, Brad Jump of Otter Slough Conservation Area, Wanda Doolen of Sam A. Baker State Park, Bruce Schuette of Cuivre River State Park, Cindy Hall and Jocelyn Korsch of Ozark Caverns, Merle Rogers of Roaring River State Park, Pat Whalen of Burr Oak Woods Nature Center, and Linda Richards of the U.S. Forest Service.

I would also like to thank Pola Firestone of Bookworks for her consulting work on this project. Her expert advice has paved a smooth road for me to travel upon.

Last but by no means least, a great big thank you to Susan Anderson of Midwestock for her advice, humor and encouragement.

The photographs and text in this book are an invitation, an enticement for you to discover and explore natural Missouri. I hope many of you will read the captions and travel to the places pictured in this book.

Before you set out on your adventure, I must issue a word of caution: don't expect to find exactly what you see in this book. What you find will be better than anything I can put on film - the real experience of finding the extraordinarily beautiful. These really special encounters with nature frequently happen outside of your expectations. To make the most of your visit, take a frame of mind free of those expectations and full of open anticipation.

In addition to creating memories for a lifetime, exploring the natural landscape also provides a psychological or spiritual renewal. If we can leave schedules and agendas back home, our experiences in nature allow our minds to slow down, to become less frenetic and compulsive. The mind can then rest in the quiet progression of natural events, like watching azure blue spring water flow languidly downstream, or listening to the call of a Whippoorwill rise from an Ozark valley at dawn.

Creating this kinship with Nature is deeply gratifying. There is a spirit in nature that breathes from the dark entrance of a cave, radiates from a Dogwood blossom, or penetrates from the noble stare of an 8-point whitetailed deer. Naming this spirit is not important, but experiencing it is. Being in wild places, without deadlines, without expectations, we may for an instant abandon all thought, leaving only the exhilaration of this benevolent, creative spirit coursing through us. Instead of feeling isolated and alone, we can experience how nature connects us all.

I hope this book inspires you to seek out and discover the wonderfully preserved natural areas of Missouri. By doing so we can see the tangible relevance of nature in our lives, and earnestly support the conservation of wild places.

An Invitation

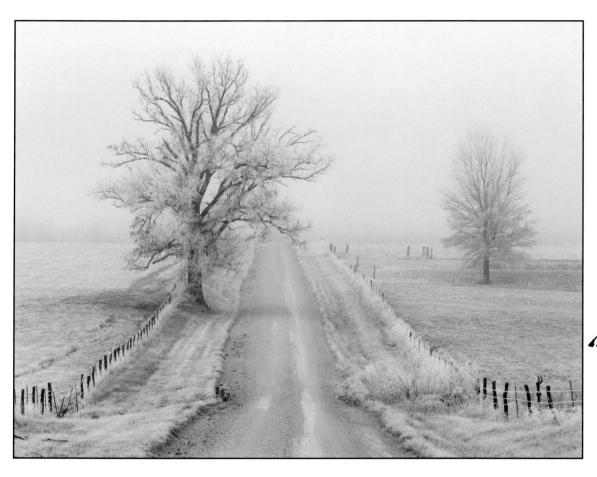

"*What* lies behind us and what lies before us are tiny matters compared to what lies within us. "

■ RALPH WALDO EMERSON

HOARFROST AND LIFTING FOG, RURAL CASS COUNTY

"*H*eaven is under our feet
as well as over our heads."

■ HENRY DAVID THOREAU

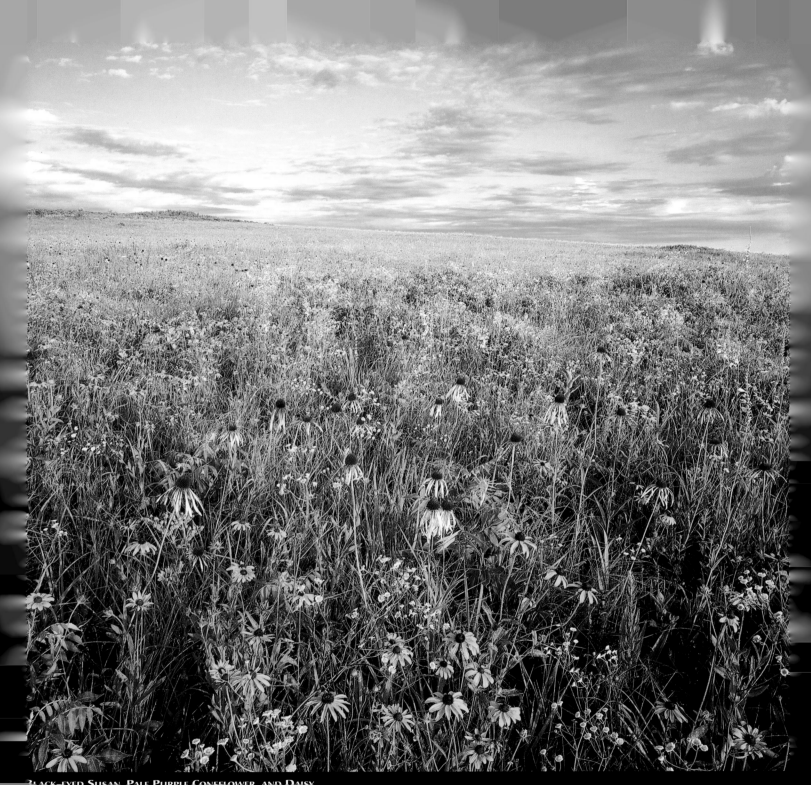

Black-eyed Susan, Pale Purple Coneflower, and Daisy

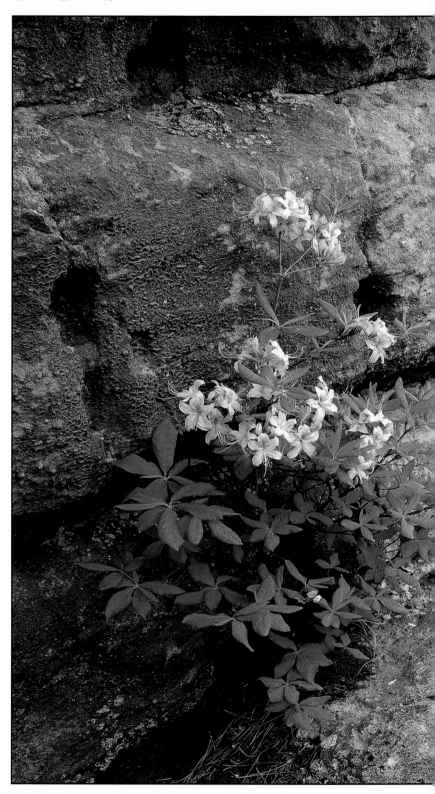

"*I* went to the woods because I wished to live deliberately, to front only the essential facts of life, and see if I could not learn what it had to teach, and not, when I came to die, discover that I had not lived."

■ HENRY DAVID THOREAU

AZALEA, HAWN STATE PARK, SAINT GENEVIEVE COUNTY

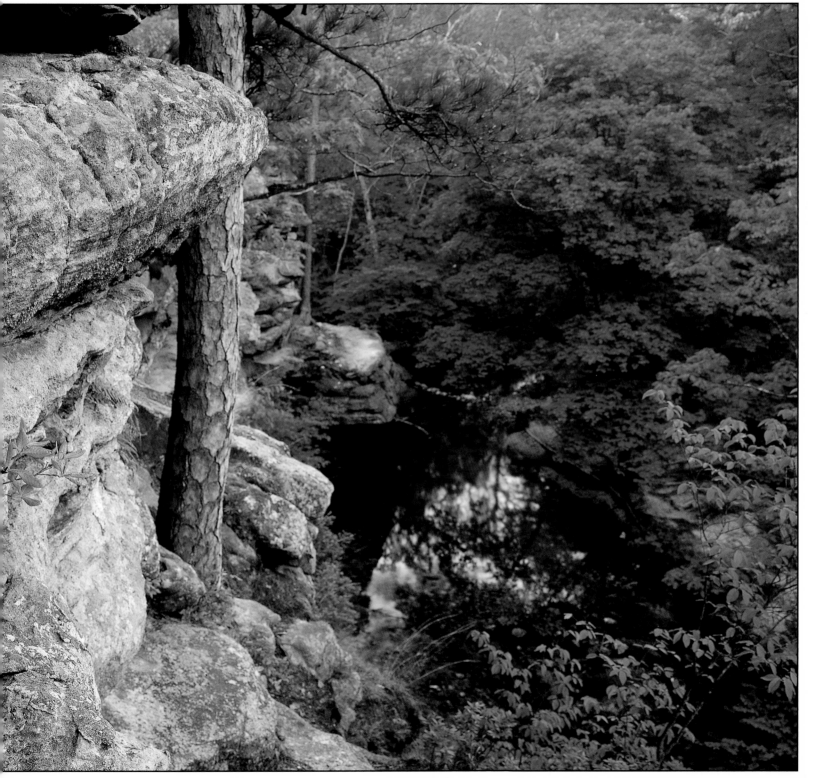

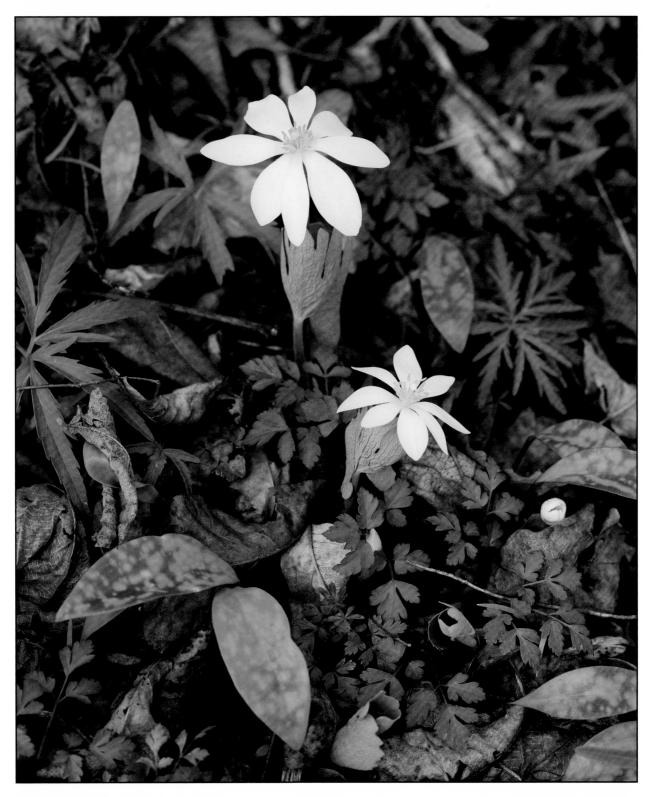

"The Great Spirit is our
Father, but the Earth is our
Mother. She nourishes us;
that which we put into the
ground she returns to us…"

■ BIG THUNDER,
ALGONQUIN INDIAN

BLOODROOT BLOSSOMS, ROARING RIVER STATE PARK, BARRY COUNTY

"The most beautiful
experience we can have
is the mysterious. It is
the fundamental emotion
which stands at the
cradle of true art and
true science."

■ ALBERT EINSTEIN

INDIAN PAINTBRUSH ON ROCKY TOP GLADE, LAKE OF THE OZARKS STATE PARK, CAMDEN COUNTY

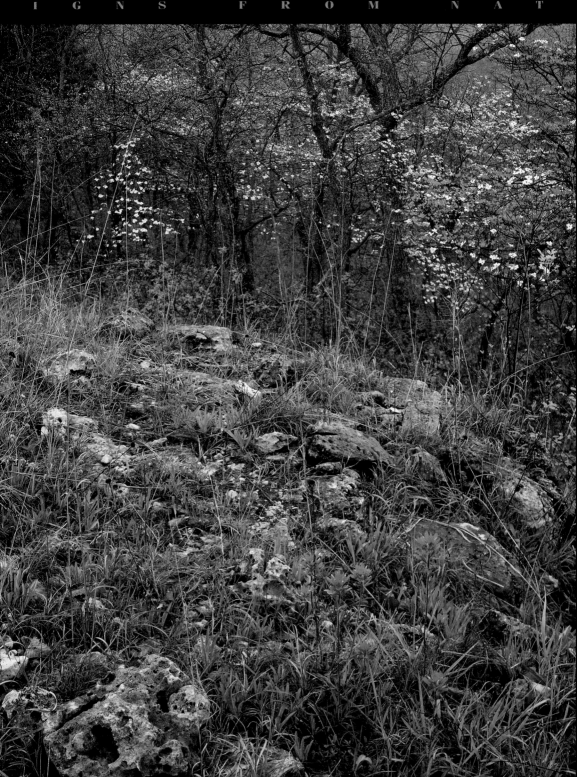

"To see a world in a grain of sand
And heaven in a wild flower
Hold infinity in the palm of your hand
And eternity in an hour."

■ WILLIAM BLAKE

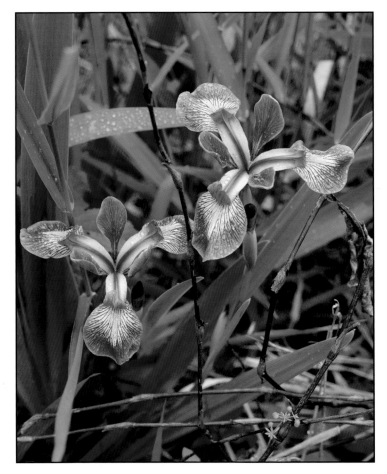

**BLUE FLAG IRIS,
SQUAW CREEK NATIONAL WILDLIFE REFUGE, HOLT COUNTY**

BLACK-EYED SUSANS AND LEADPLANT, GOLDEN PRAIRIE, BARTON COUNTY

16

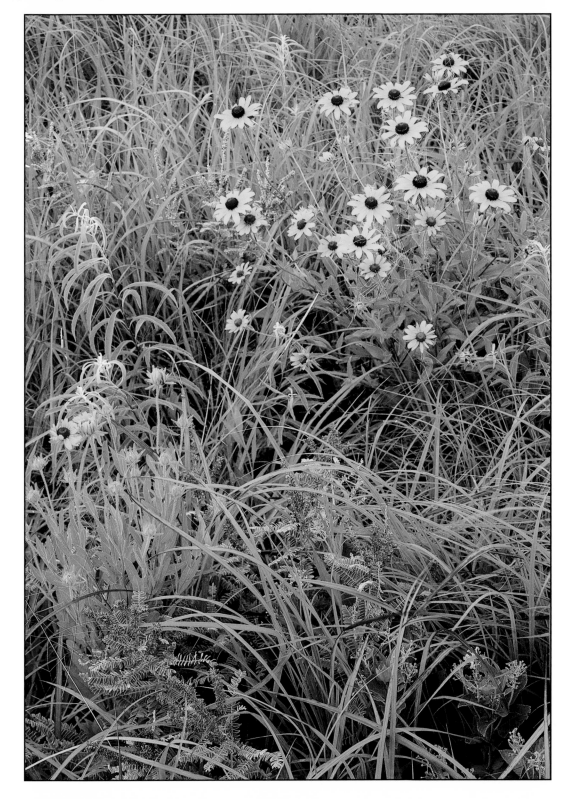

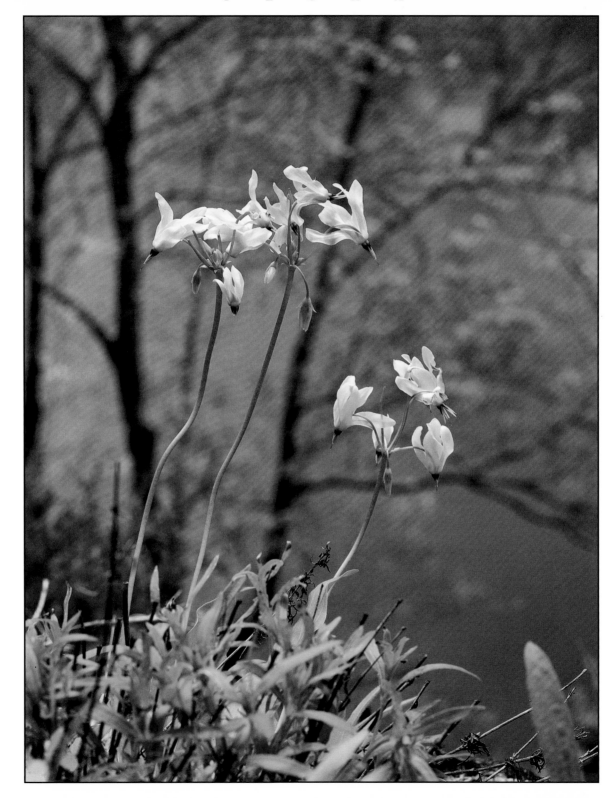

*"*W*herever we go in the Wilderness, we find more than we seek.*"*

■ JOHN MUIR

SHOOTING STAR, DEVIL'S BACKBONE WILDERNESS, OZARK COUNTY

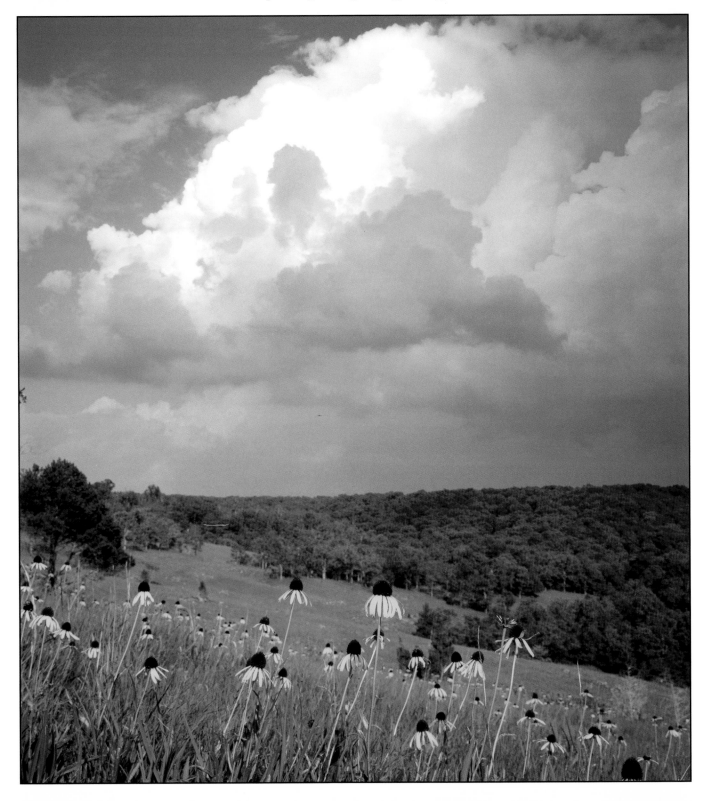

"*Thank God they can't cut down the clouds!*"

■ HENRY DAVID THOREAU

YELLOW CONEFLOWERS AT LODGE GLADE, HA HA TONKA STATE PARK, CAMDEN COUNTY

"*W*here there is joy there
is creation. Where there is
no joy there is no creation:
know the nature of joy."

■ **Upanishads (800 B.C.)**

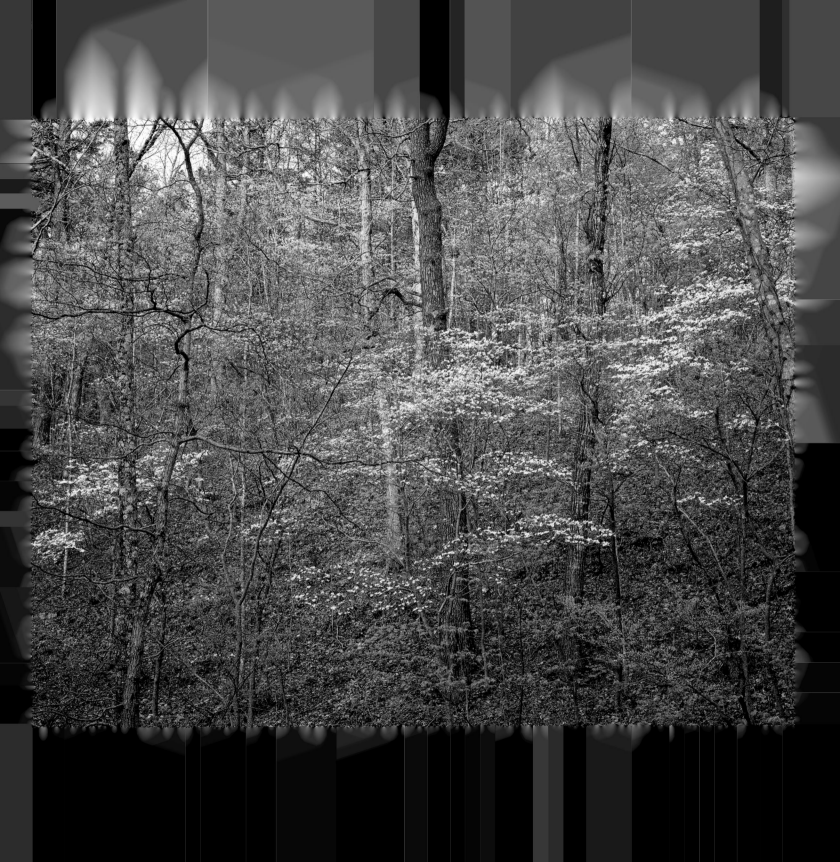

"*The* tendency nowadays
to wander in wilderness is
delightful to see. Thousands
of tired, over-civilized
people are beginning to
find out that going to the
mountains is going home;
that wildness is a necessity;
and that mountain parks
and reservations are useful
not only as fountains of
timber and irrigating rivers,
but as fountains of life."

■ JOHN MUIR

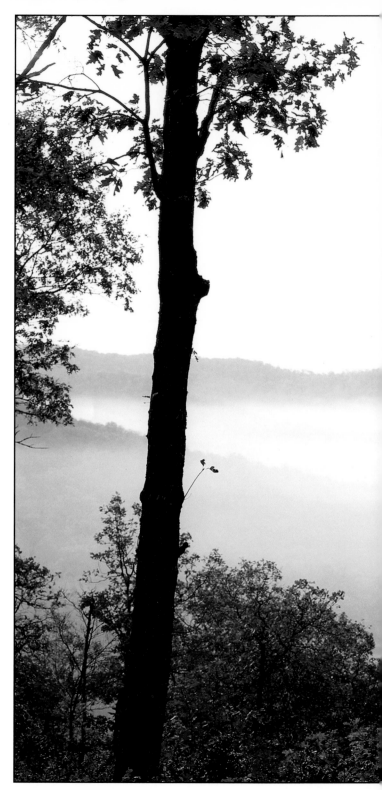

FOG LIFTING FROM OZARK VALLEYS,
MARK TWAIN NATIONAL FOREST, BARRY COUNTY

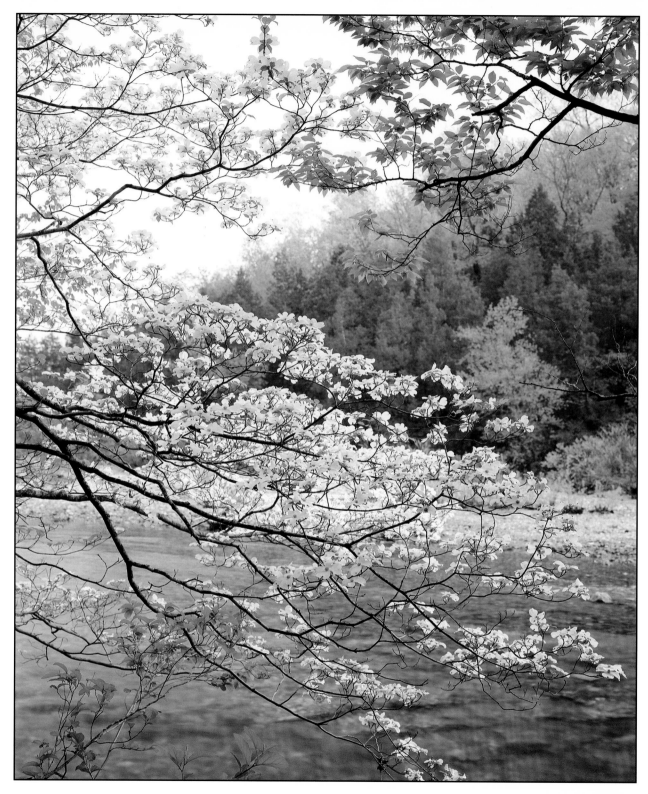

"People say that what we're all seeking is a meaning for life…I think that what we're really seeking is an experience of being alive, so that our life experiences on the purely physical plane will have resonance within our innermost being and reality, so that we can actually feel the rapture of being alive."

■ JOSEPH CAMPBELL

DOGWOOD BRANCHES ABOVE EAST FORK BLACK RIVER, JOHNSON'S SHUT-INS STATE PARK, REYNOLDS COUNTY

"*W*hen the forest
murmurs there is music:
ancient, everlasting."

■ FIONA MACLEOD

FALL COLORS ALONG THE ELEVEN POINT RIVER, OREGON COUNTY

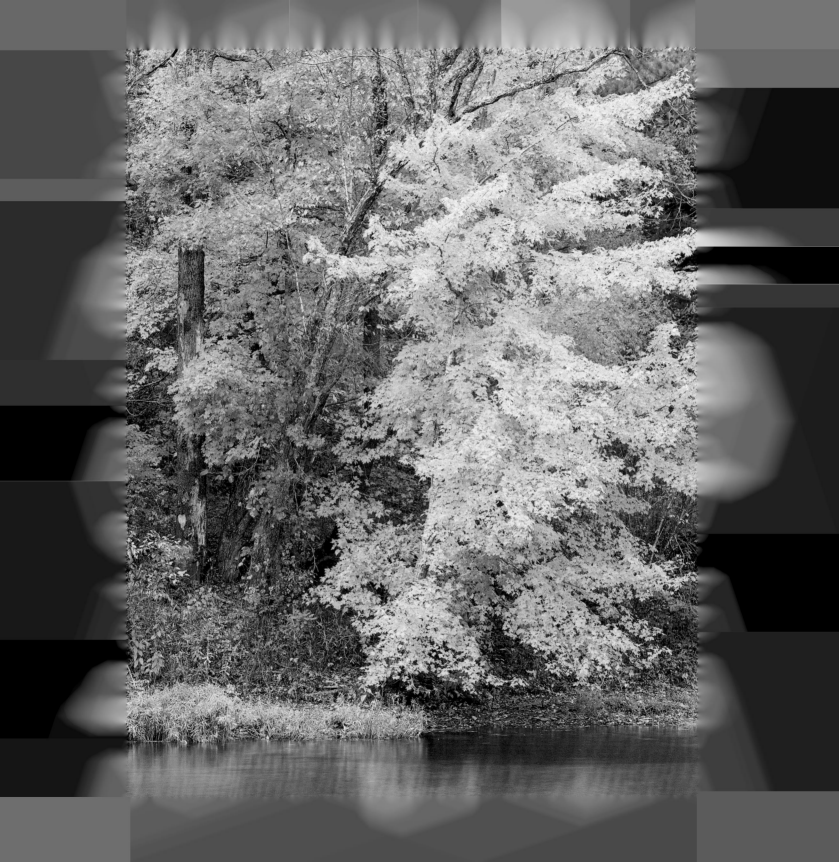

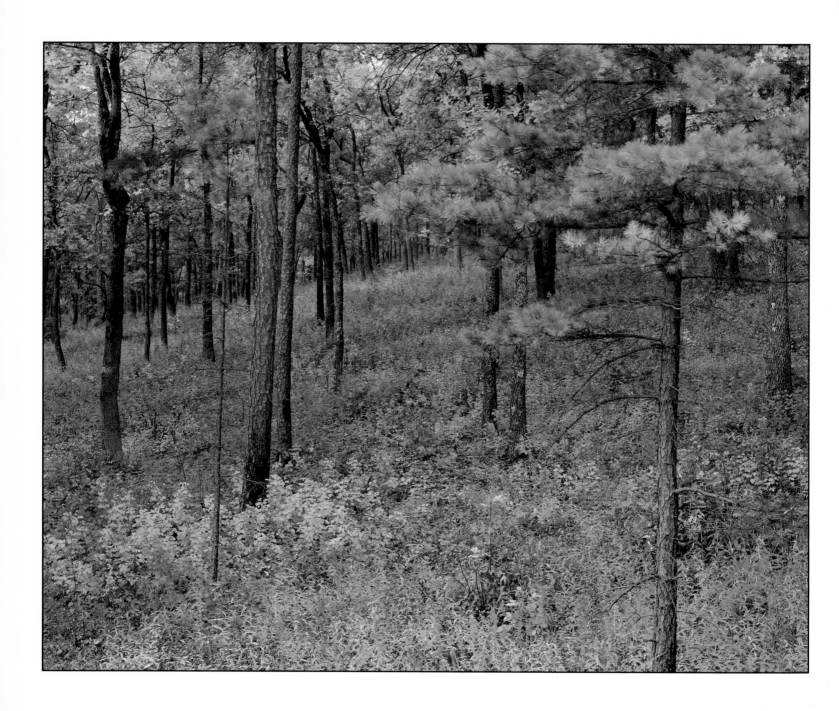

Savannas are areas with widely spaced trees where prairie grasses and wildflowers grow underneath the tree canopy. Much of the Ozark forests were characterized as savannas prior to the clear cutting of virtually the entire region in the late 1800's and early 1900's. Reforestation efforts have led to the much more dense forests we find in the region today. This is one of several outstanding examples of restored savannas at Hawn State Park, Saint Genevieve County.

"*The young pine knows the secrets of the ground. The old pine knows the stars.*"

■ AUTHOR UNKNOWN

RESTORED SAVANNA, HAWN STATE PARK, SAINT GENEVIEVE COUNTY

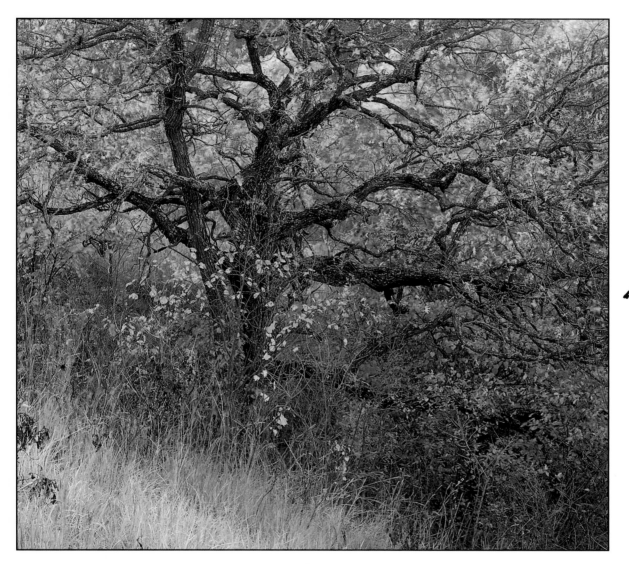

"This we know: the earth does not belong to man, man belongs to the earth. All things are connected like the blood that unites us all. Man did not weave the web of life, he is merely a strand in it. Whatever he does to the web, he does to himself."

■ CHIEF SEATTLE

BURR OAK ON LOESS HILLSIDE,
JAMERSON C. McCORMACK
CONSERVATION AREA, HOLT COUNTY

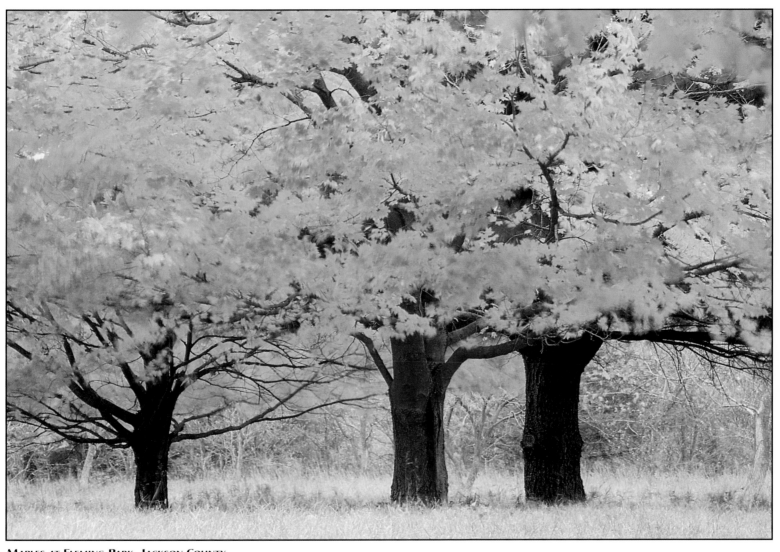

MAPLES AT FLEMING PARK, JACKSON COUNTY

"*Life* consists with wildness. The most alive is the wildest. Not yet subdued to man, its presence refreshes him."

■ HENRY DAVID THOREAU

SPRING WAKES THE MARK TWAIN NATIONAL FOREST, BARRY COUNTY

35

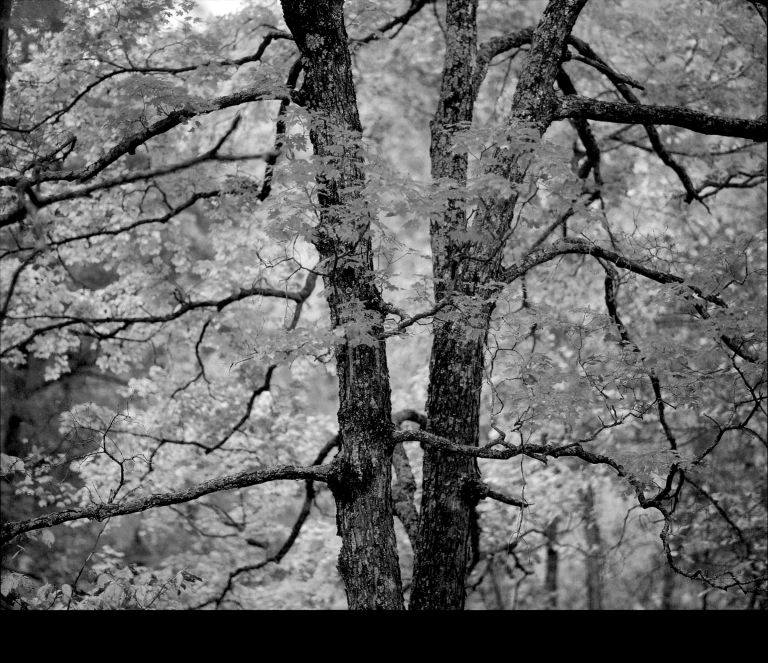

> *"The greatest wonder is that we can see these trees and not wonder more."*
>
> ■ **RALPH WALDO EMERSON**

RED MAPLE, HA HA TONKA STATE PARK, CAMDEN COUNTY

"*P*eace ... comes within the souls of men when they realize their relationship, their oneness, with the Universe and all its powers, and when they realize that at the center of the Universe dwells Wakan – Tanka (Great Spirit), and that this center is really everywhere, it is within each of us. "

■ **BLACK ELK**

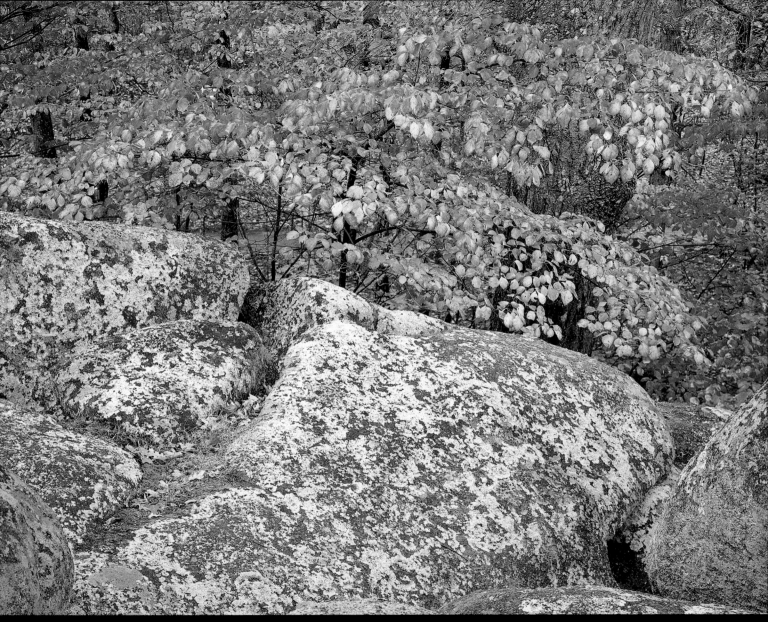

GRANITE BOULDERS AND DOGWOOD TREE,
ELEPHANT ROCKS STATE PARK, IRON COUNTY

39

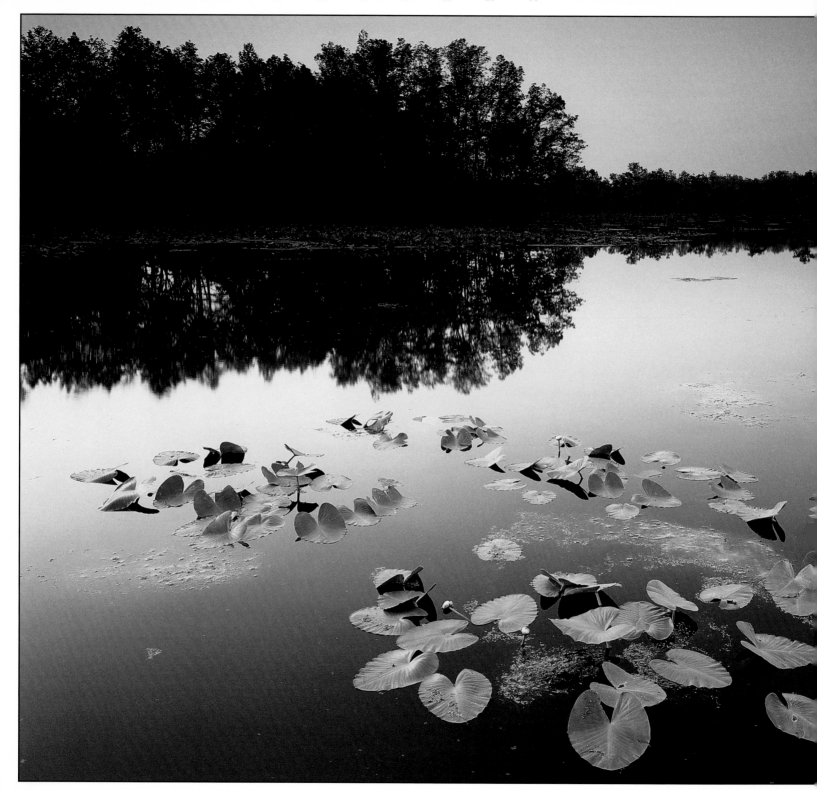

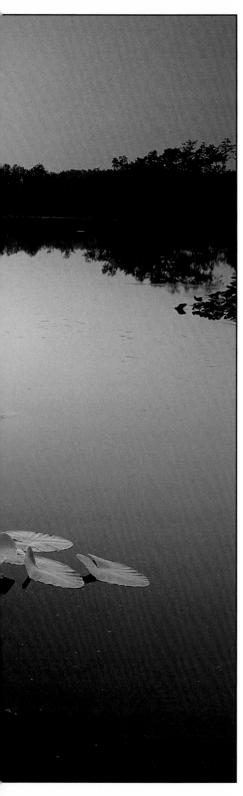

"*N*ature is an infinite
sphere, of which the
center is everywhere, the
circumference nowhere."

■ **BLAISE PASCAL**

**AMERICAN LOTUS AT OTTER SLOUGH
CONSERVATION AREA, STODDARD COUNTY**

"*There* is nothing dead in nature. Everything is organic and living, and therefore, the whole world appears to be a living organism."

■ **SENECA (3 B.C. – 65 A.D.)**

SYCAMORE TREE ALONG THE SHORE OF THE MISSOURI RIVER, PLATTE COUNTY

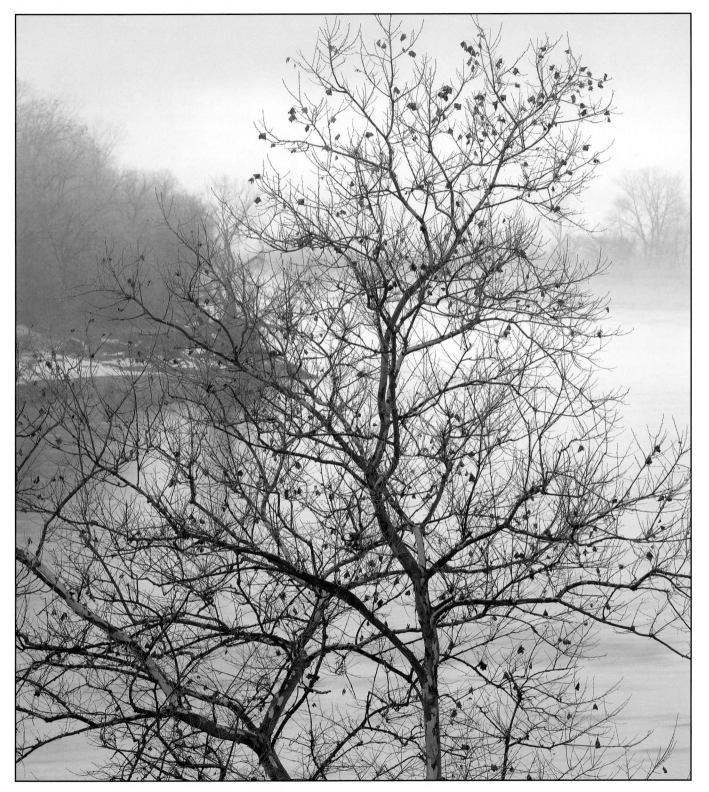

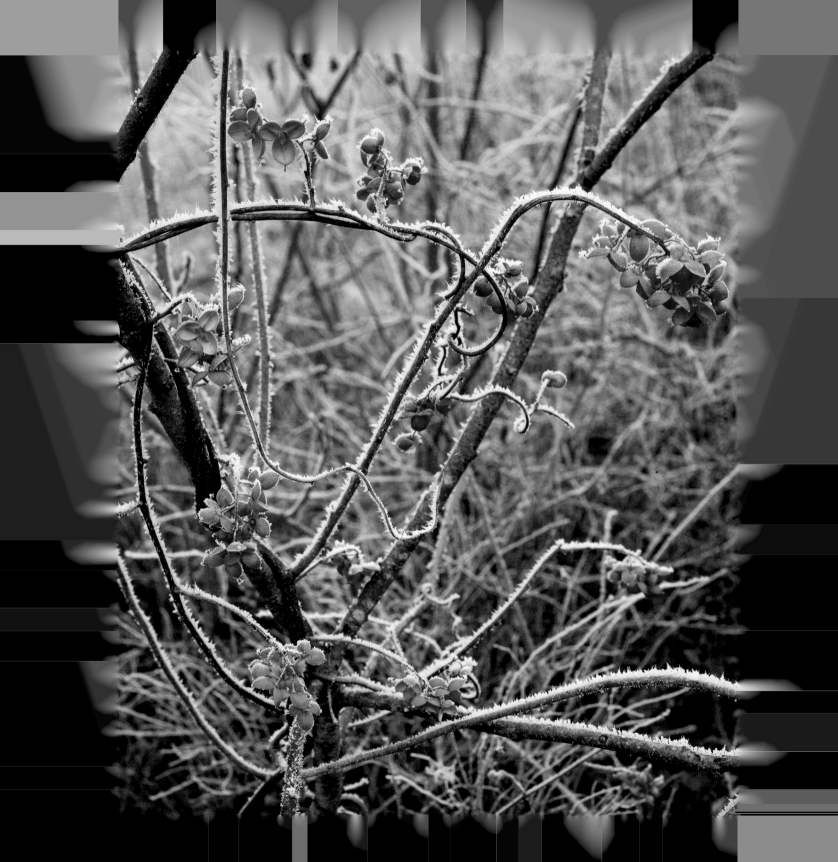

"*A*dopt the pace of nature, her secret is patience."

■ **RALPH WALDO EMERSON**

HOARFROST ON BITTERSWEET BERRIES, DORSETT HILL PRAIRIE, CASS COUNTY

"The finest workers in stone are not copper or steel tools, but the gentle touches of air and water working at their leisure with a liberal allowance of time."

■ HENRY DAVID THOREAU

SNOW PATTERNS ON SANDSTONE BOULDERS, HAWN STATE PARK, SAINT GENEVIEVE COUNTY

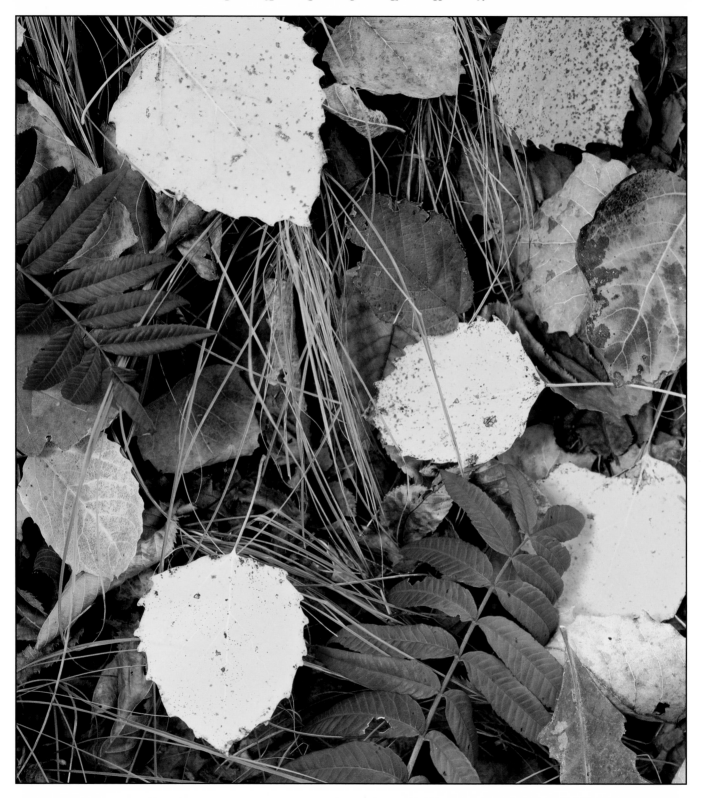

"The last word in ignorance is the man who says of an animal or plant: 'What good is it?'... If the biota, in the course of aeons, has built something we like but do not understand, then who but a fool would discard seemingly useless parts? To keep every cog and wheel is the first precaution of intelligent tinkering."

■ ALDO LEOPOLD

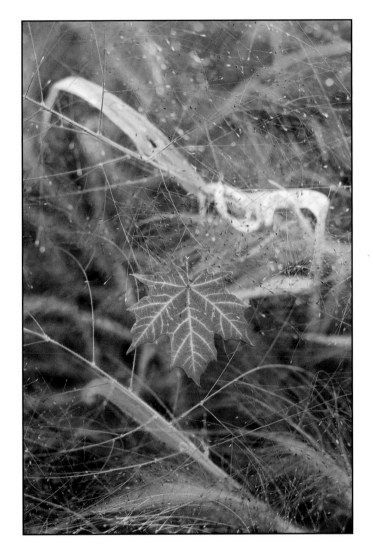

SUGAR MAPLE LEAF IN SWITCH GRASS, WATKINS WOOLEN MILL STATE PARK, CLAY COUNTY

ASPEN AND SUMAC LEAVES, THOUSAND HILLS STATE PARK, ADAIR COUNTY

"Nothing is rich but the inexhaustible wealth of nature. She shows us only surfaces but she is million fathoms deep."

■ RALPH WALDO EMERSON

RED MAPLE ABOVE PICKLE CREEK, HAWN STATE PARK, SAINT GENEVIEVE COUNTY

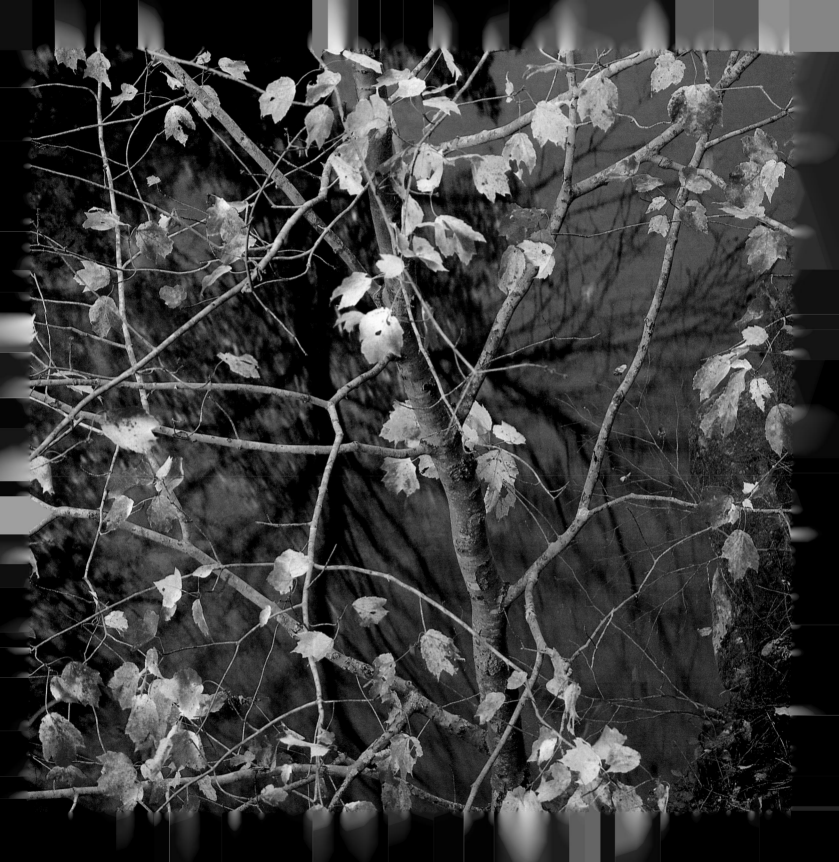

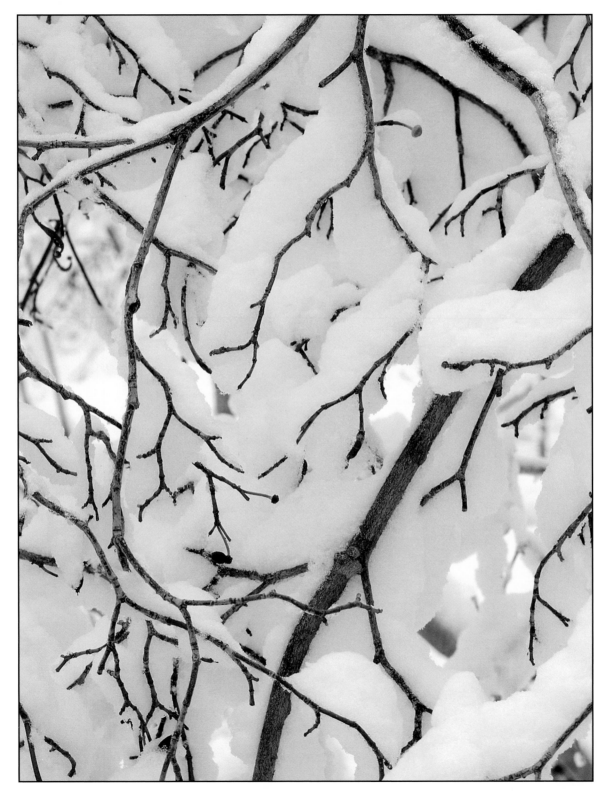

"*Life forms no logical patterns. It is haphazard and full of beauties which I try to catch as they fly by, for who knows whether any of them will ever return.*"

■ **DAME MARGOT FONTEYN**

SNOW-COVERED DOGWOOD BRANCHES, HA HA TONKA STATE PARK, CAMDEN COUNTY

"
...we should even be
as water, which is lower
than all things, yet stronger
even than the rocks."

■ **BLACK ELK**

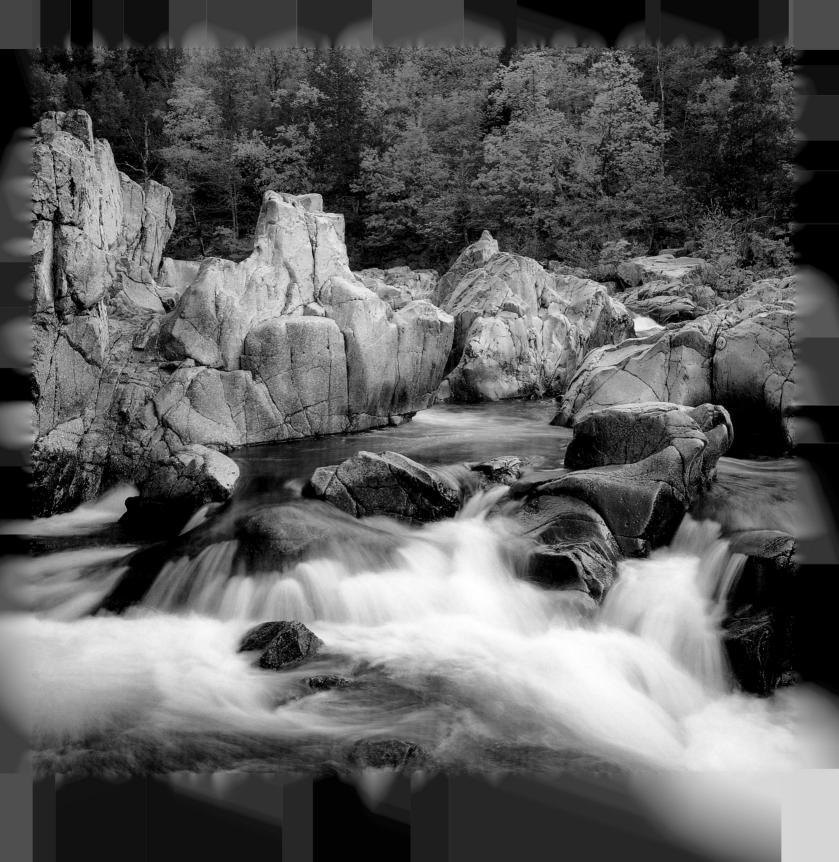

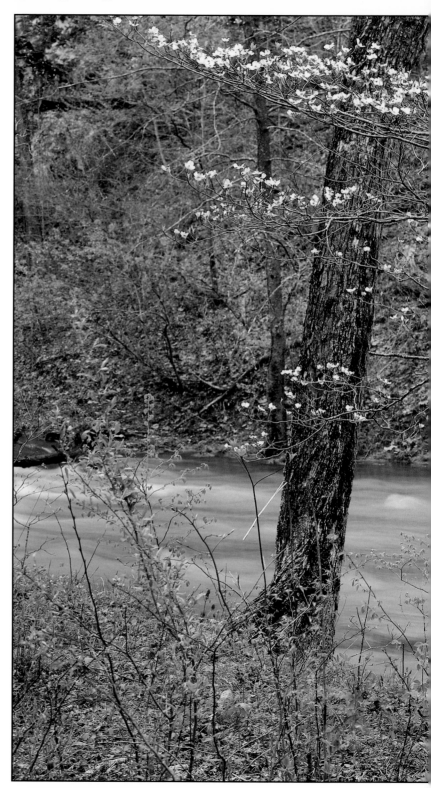

"*T*rue silence is the rest of the mind; and it is to the spirit what sleep is to the body, nourishment and refreshment."

■ WILLIAM PENN

DOGWOOD AND CURRENT FROM BLUE SPRING, OZARK
NATIONAL SCENIC RIVERWAYS, SHANNON COUNTY

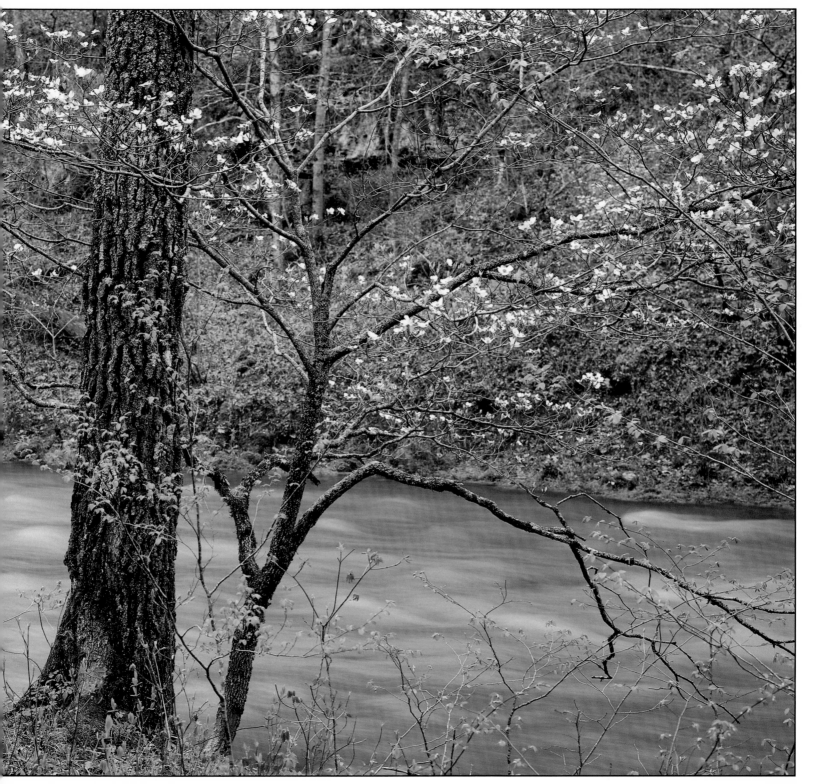

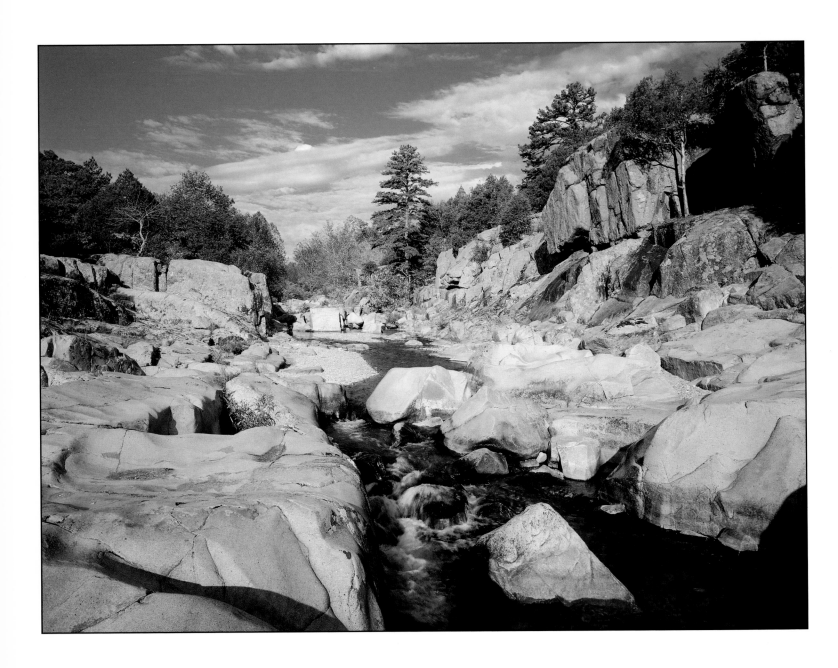

"*There is more to life than increasing its speed.*"

■ MAHATMA GANDHI

CASTOR RIVER SHUT-INS, AMIDON MEMORIAL
CONSERVATION AREA, BOLLINGER COUNTY

"There is quiet water
In the center of your soul,
Where a son or daughter
Can be taught what no
man knows."

■ JAMES KAVANAUGH

REFLECTIONS AT LAKE RIPLEY, RIPLEY COUNTY

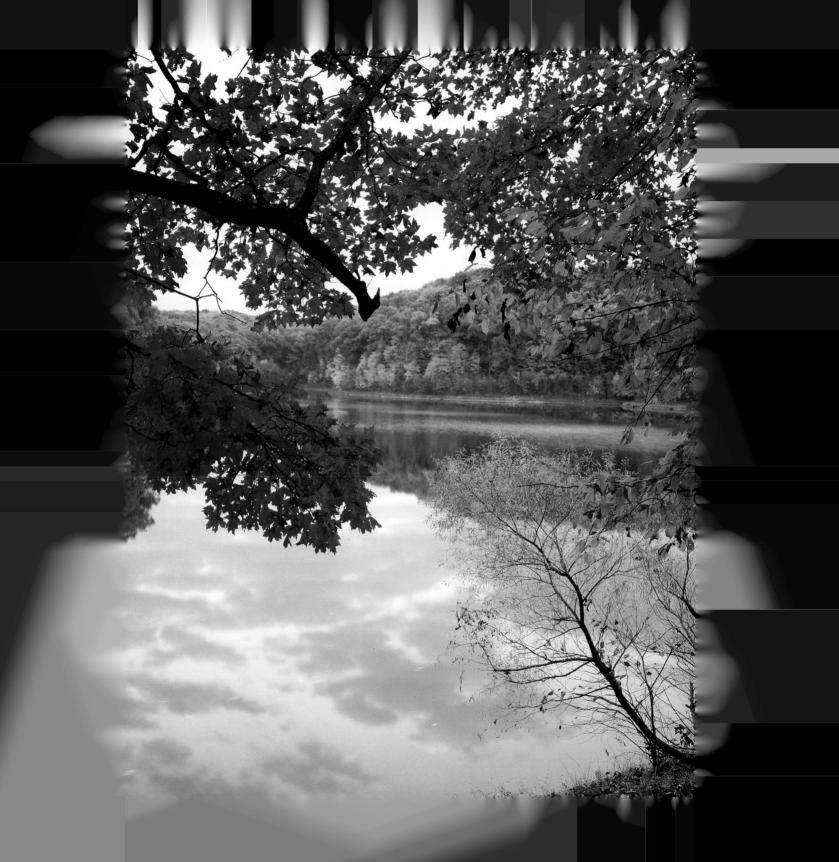

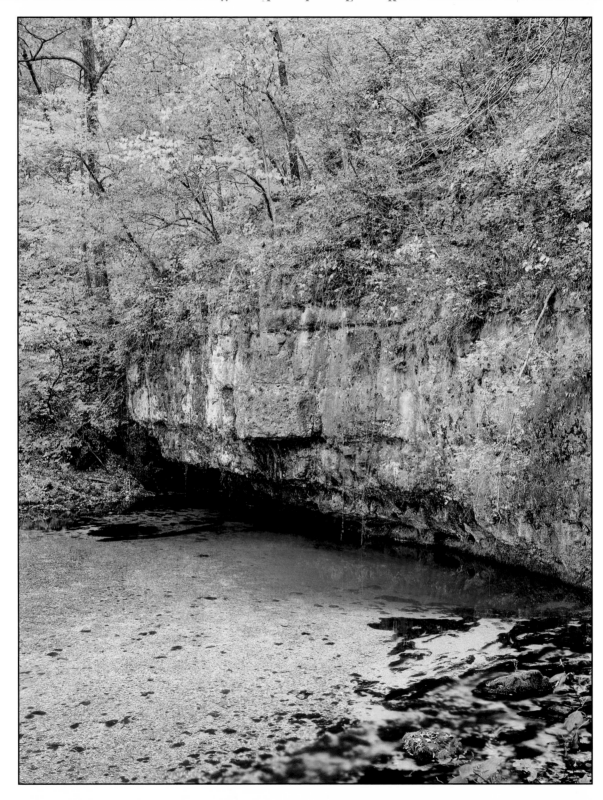

"Standing on
the bare ground ...
all mean egotism vanishes.
I become a transparent
eyeball; I am nothing;
I see all; the currents
of the Universal Being
circulate through me;
I am part or particle
of God."

■ RALPH WALDO EMERSON

HA HA TONKA SPRING, HA HA TONKA STATE PARK, CAMDEN COUNTY

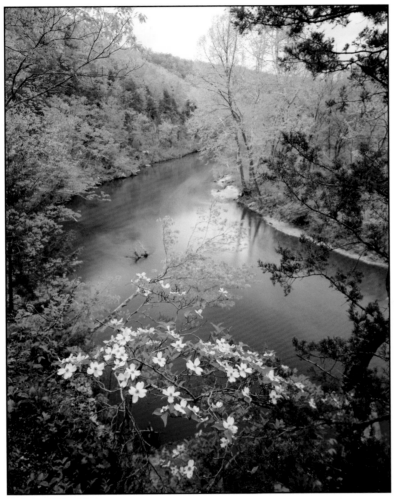

DOGWOOD BLOSSOMS ABOVE THE NORTH FORK OF THE WHITE RIVER,
DEVIL'S BACKBONE WILDERNESS, OZARK COUNTY

"The shining water that moves in the streams and rivers is not just water, but the blood of our ancestors. If we sell you our land, you must remember that it is sacred. Each ghostly reflection in the clear water of the lakes tells of events and memories in the life of my people. The water's murmur is the voice of my father's father."

■ CHIEF SEATTLE

WATERFALL AT COWARD'S
HOLLOW NATURAL AREA,
MARK TWAIN NATIONAL FOREST,
CARTER COUNTY

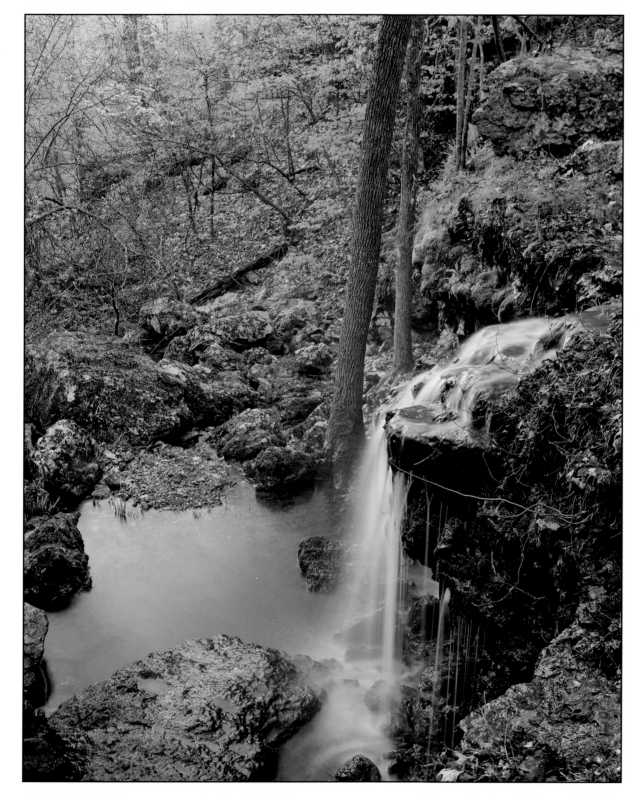

"Water is H₂0, hydrogen two parts, oxygen one, but there is also a third thing that makes it water and nobody knows what that is."

■ **D. H. Lawrence**

Castor River Shut-Ins, Amidon Memorial Conservation Area, Bollinger County

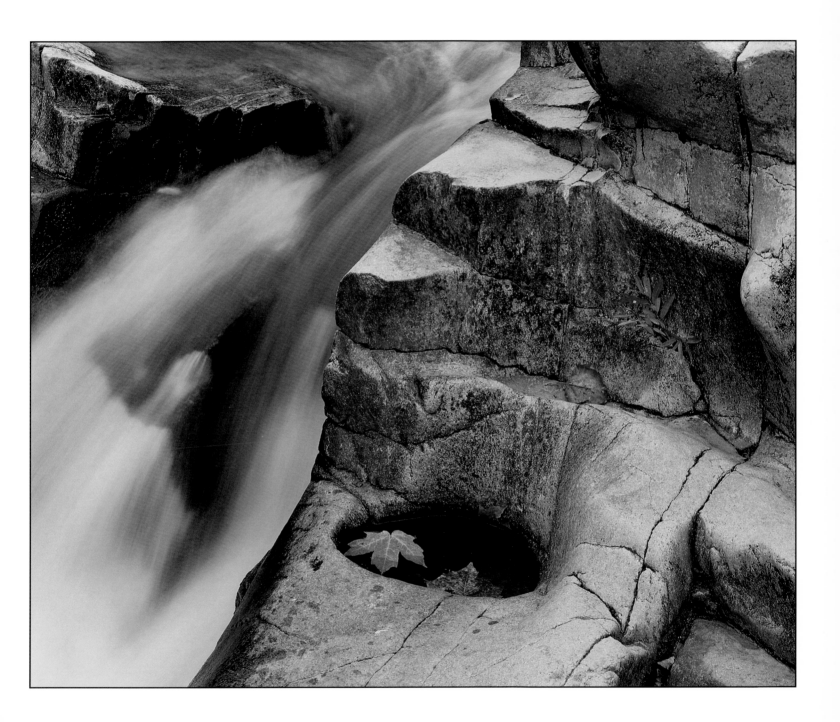

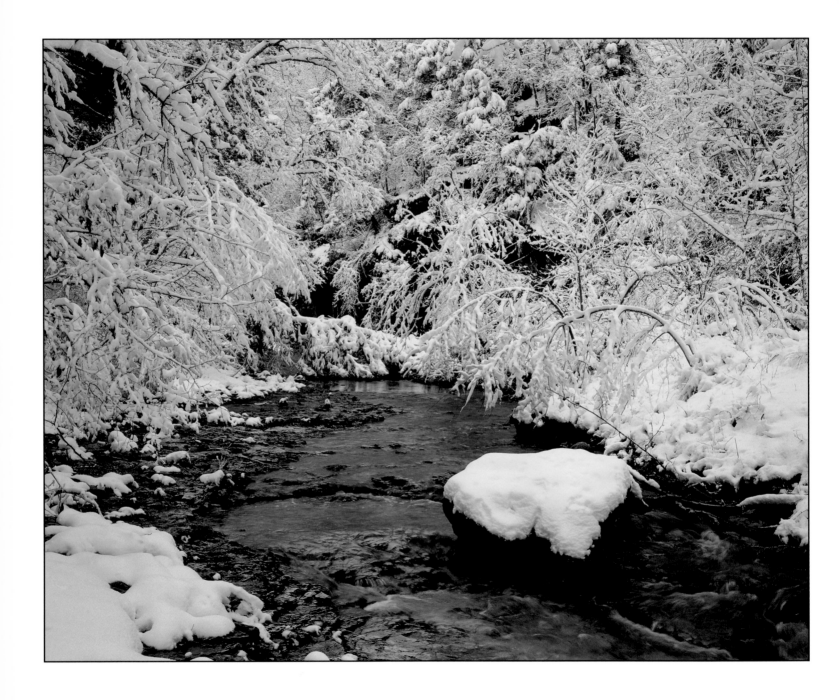

"*There is a peculiar charm in a spot unknown to the many. Its loneliness endears it to the mind, and gives its association a rarer flavor.*"

■ **FRANK BOLLES**

CLIFTY CREEK NATURAL AREA, MARIES COUNTY

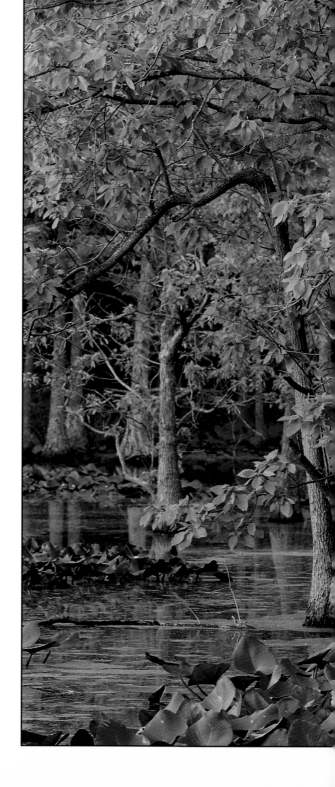

"*A*nd this, our life, exempt from public haunt, finds tongues in trees, books in the running brooks, sermons in stones, and good in everything."

■ WILLIAM SHAKESPEARE

TUPELO AND CYPRESS TREES AT ONE OF THE BEST AND VERY FEW REMAINING EXAMPLES OF HOW THE MISSOURI BOOTHEEL USED TO LOOK BEFORE SETTLEMENT. OTTER SLOUGH CONSERVATION AREA, STODDARD COUNTY

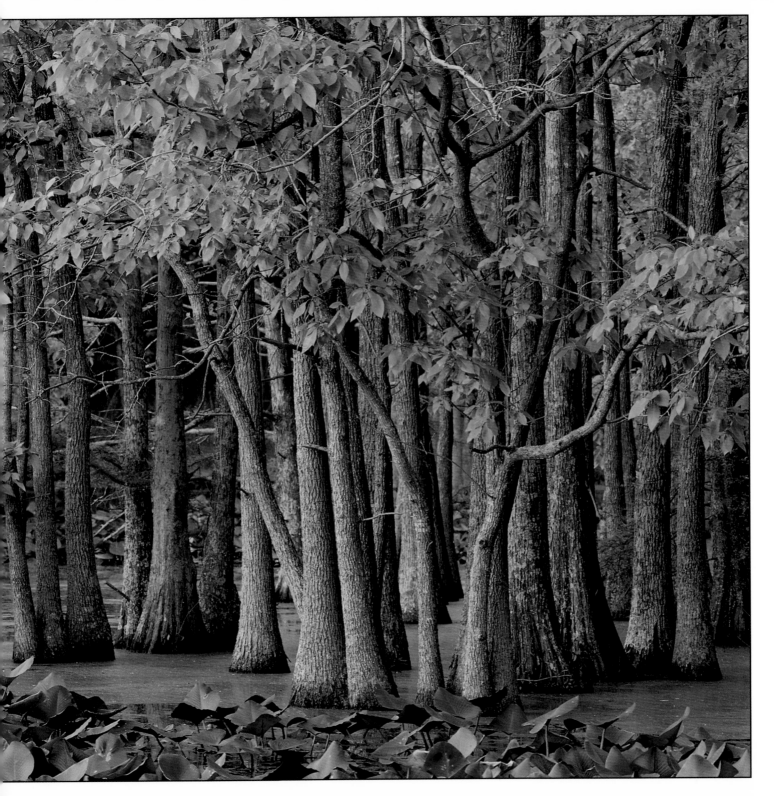

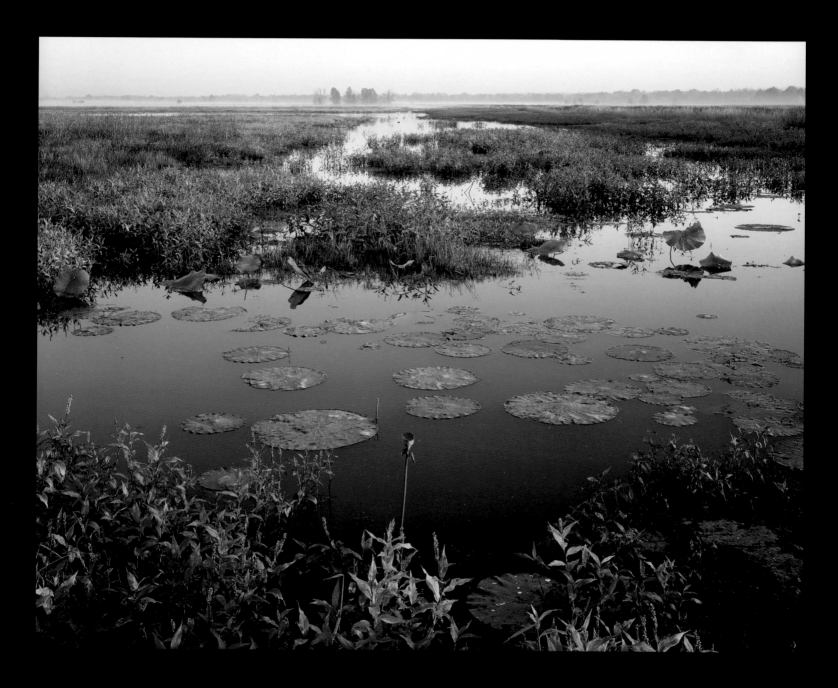

"*I*t depends on those
who pass, whether I
am a tomb or a treasure,
whether I speak or I
am silent.

■ ANONYMOUS

LOTUS LEAVES AT TED SHANKS CONSERVATION AREA, PIKE COUNTY

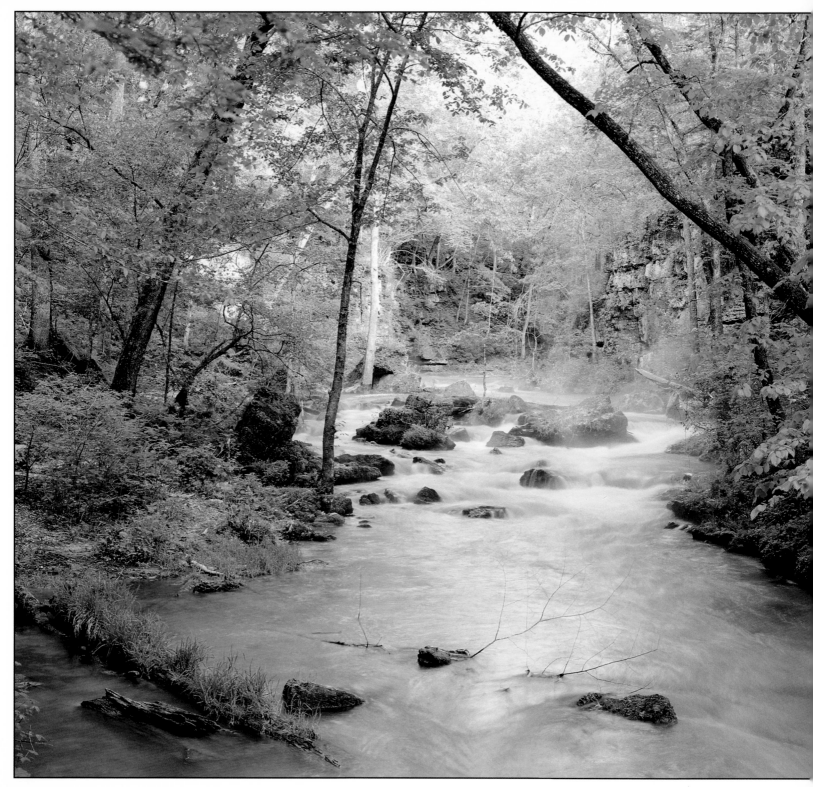

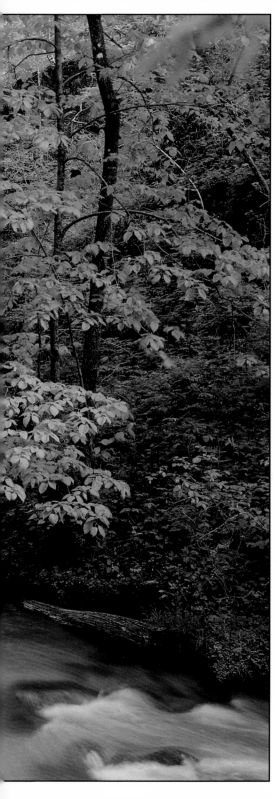

"There is pleasure in
the pathless woods,

There is a rapture on
the lonely shore,

There is a society
where none intrudes,

By the deep sea, and
music in its roar:

I love not man the less,
but nature more."

■ LORD BYRON

EARLY SUMMER AT GREER SPRING,
MARK TWAIN NATIONAL FOREST, OREGON COUNTY

"*With* all your science
can you tell how it is,
and whence it is, that
light comes into the soul?"

■ **HENRY DAVID THOREAU**

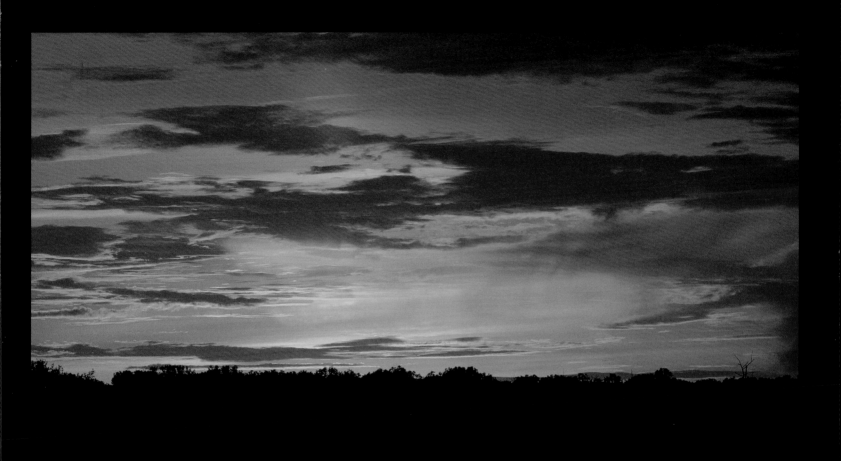

**Sunset at Duck Creek Conservation Area,
Bollinger County**

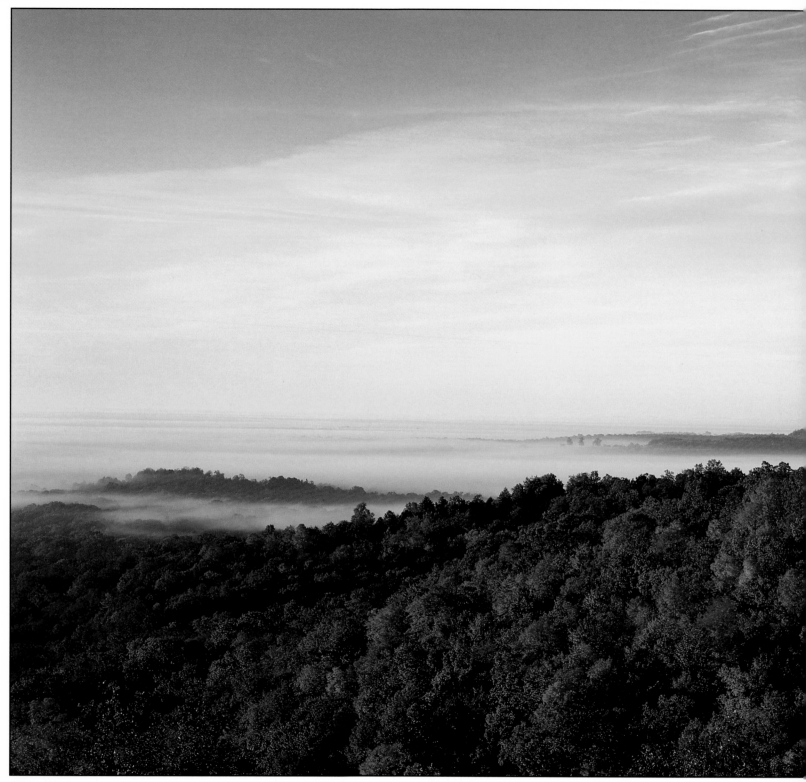

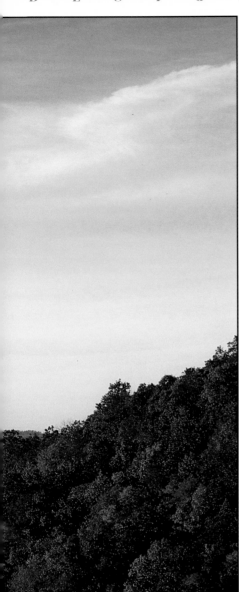

"*Earth's crammed with heaven, and every common bush afire with God: But only he who sees takes off his shoes.*"

■ ELIZABETH BARRETT BROWNING

FALL FOLIAGE ALONG
THE GLADE TOP TRAIL,
MARK TWAIN NATIONAL FOREST,
OZARK COUNTY

"*We* cannot make
America over again as
it was in the beginning,
but we can come to what
is left of our heritage with
a patriot's reverence."

■ ANONYMOUS

PALE PURPLE CONEFLOWERS AND BLACK-EYED SUSANS, SHELDON L. COOK MEMORIAL MEADOW, BARTON COUNTY

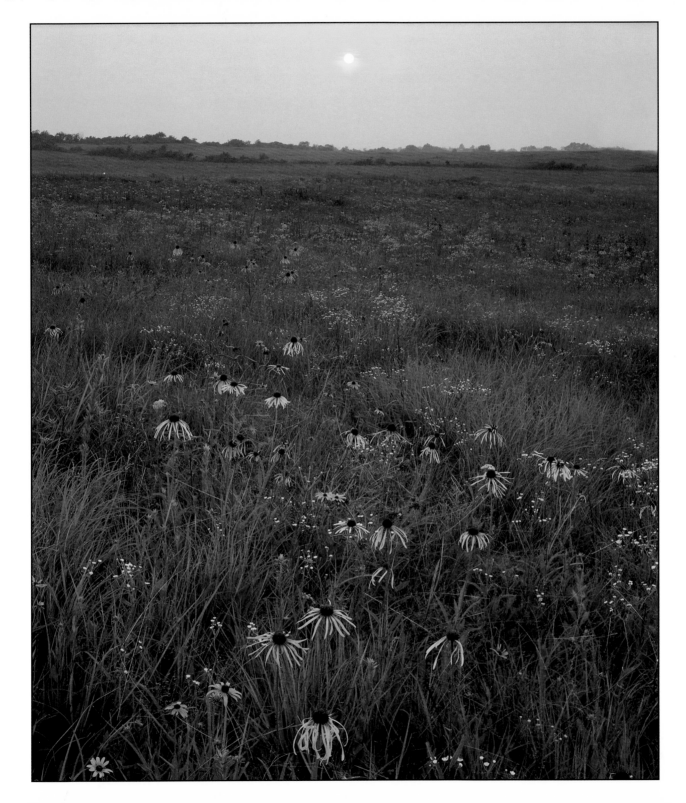

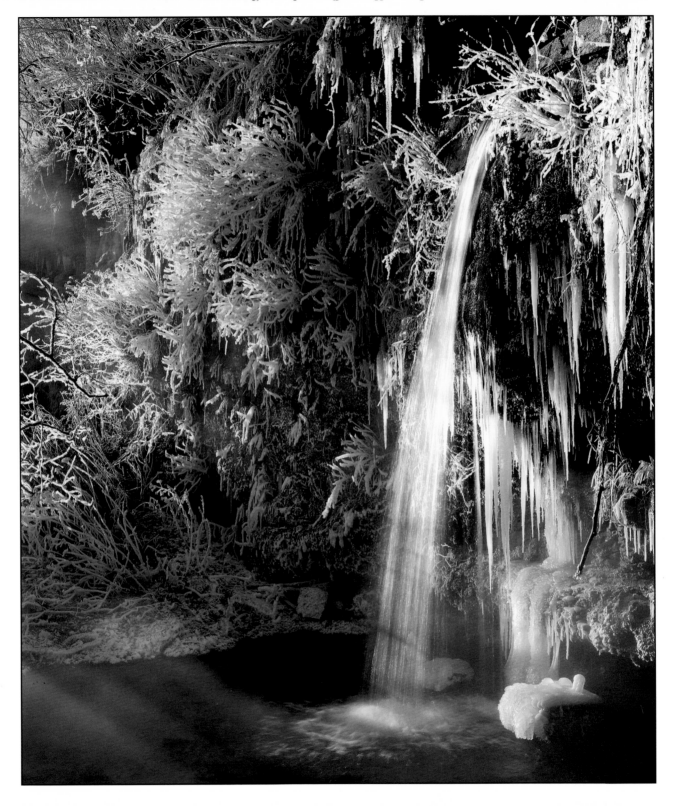

"*T*reat the earth well:
it was not given to you by
your parents, it was loaned
to you by your children."

■ **ANCIENT INDIAN PROVERB**

FALLING SPRING AT FIVE DEGREES, MARK TWAIN NATIONAL FOREST, OREGON COUNTY



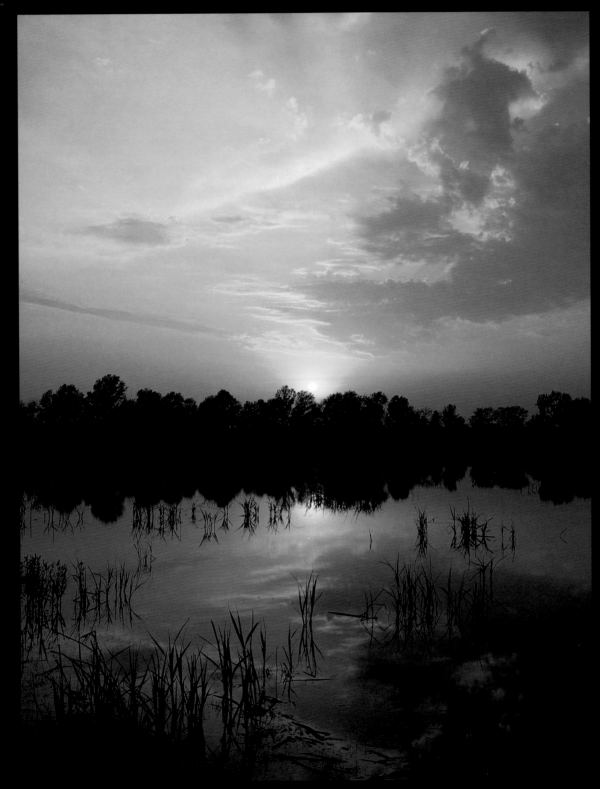

"Thus shall ye think of
this fleeting world:

A star at dawn,
a bubble in a stream,

A flash of lightning
in a summer cloud,

A flickering lamp,
a phantom, and a dream."

■ THE BUDDHA

SUNSET OVER SWAN LAKE NATIONAL WILDLIFE REFUGE, CHARITON COUNTY

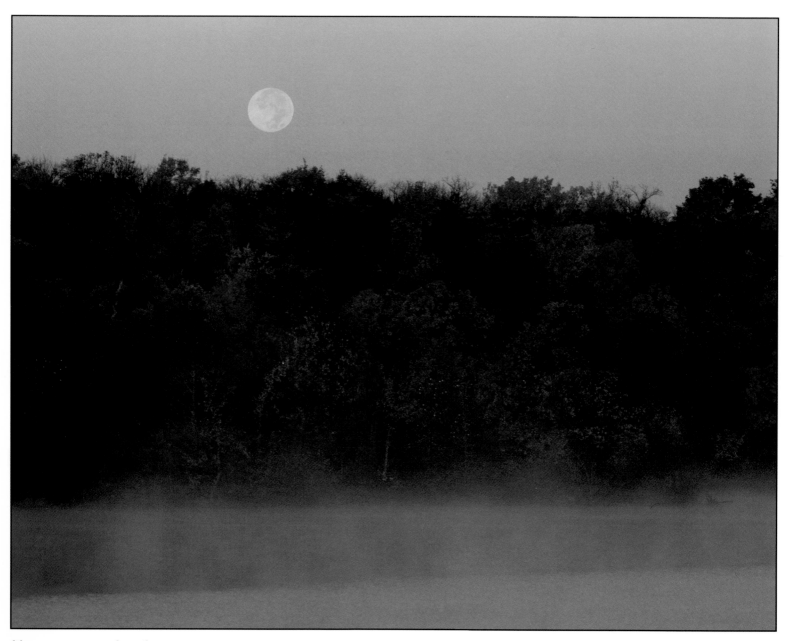

MOON SETTING OVER LAKE JACOMO,
FLEMING PARK, JACKSON COUNTY

"*H*uman completion, wholeness, or religious awakening depends on a receptive opening up to the potentialities and sacred mysteries in the immediate natural environment."

■ JOSEPH EPES BROWN

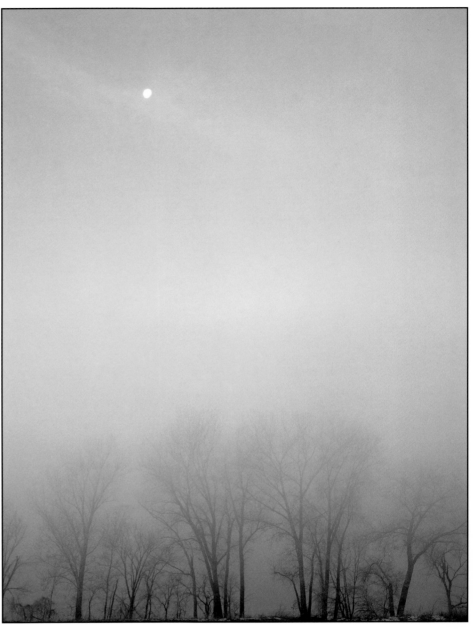

FOG LIFTING FROM THE MISSOURI RIVER, WESTON BEND STATE PARK, PLATTE COUNTY

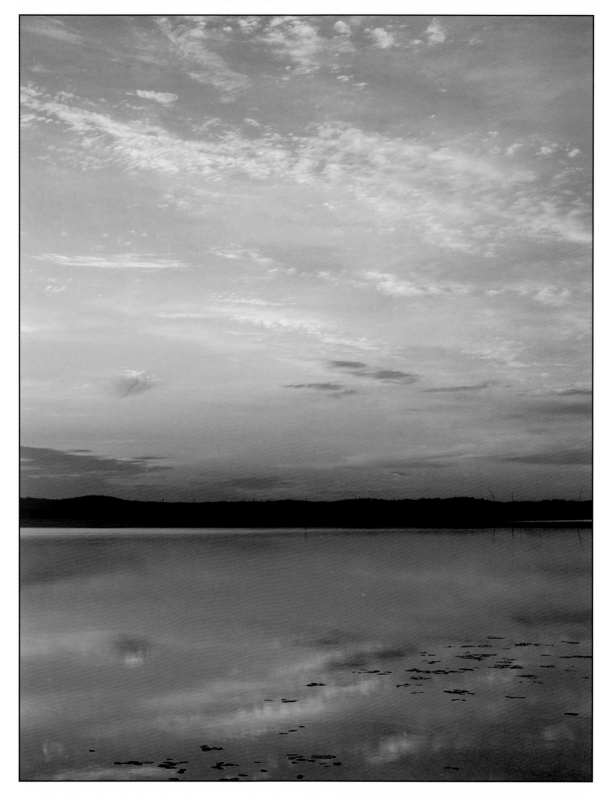

"Our ability to perceive quality in nature begins, as in art, with the pretty. It expands through successive stages of the beautiful to values as yet uncaptured by language..."

■ ALDO LEOPOLD

SUNSET OVER DUCK CREEK CONSERVATION AREA, BOLLINGER COUNTY

Fire was once a vital
component of midwest
ecology. State agencies now
perform carefully supervised
prescribed burns in areas
that will profit from it.
It is very beneficial to the
land, keeping out invasive
species and returning
nutrients to the soil. The
trees are not burned from
this fire, and in the follow-
ing spring the understory
will be invigorated with
lush grasses and woodland
wildflowers.

"*A* stern discipline
pervades all nature, which
is a little cruel that it may
be very kind."

■ EDMUND SPENSER

PRESCRIBED BURN OF FOREST UNDERSTORY, HA HA TONKA STATE PARK, CAMDEN COUNTY

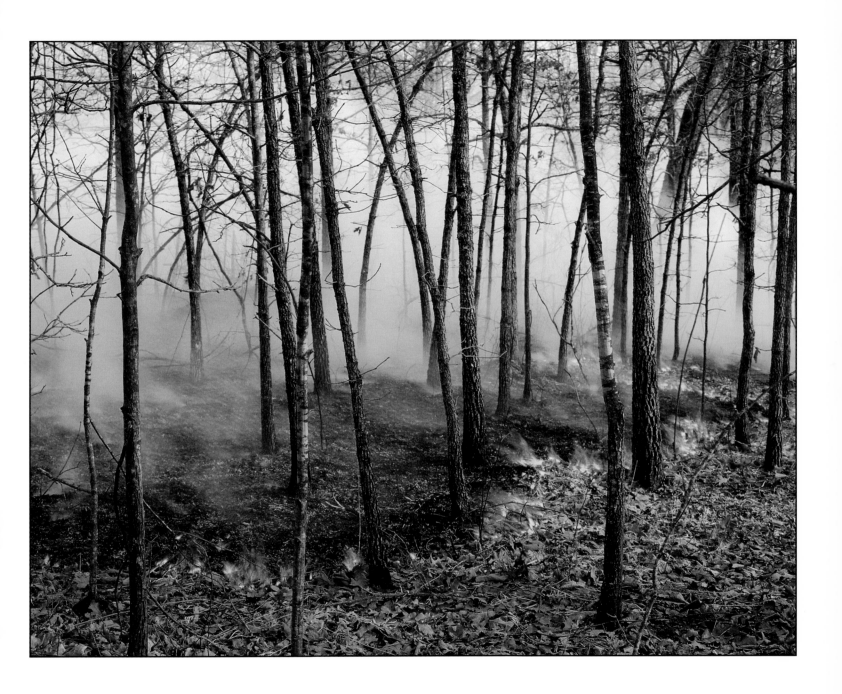

"So rests the sky against the earth ... As a husband embraces his wife's body in faithful tenderness, so the bare ground and trees are embraced by the still, high, light of the morning. I feel an ache of longing to share in this embrace, to be united and absorbed. A longing like carnal desire, but directed towards earth, water, sky, and returned by the whispers of the trees, the fragrance of the soil, the caresses of the wind, the embrace of water and light."

■ DAG HAMMARSKJOLD

CEDAR TREES SHARE A SUNSET, HENRY COUNTY

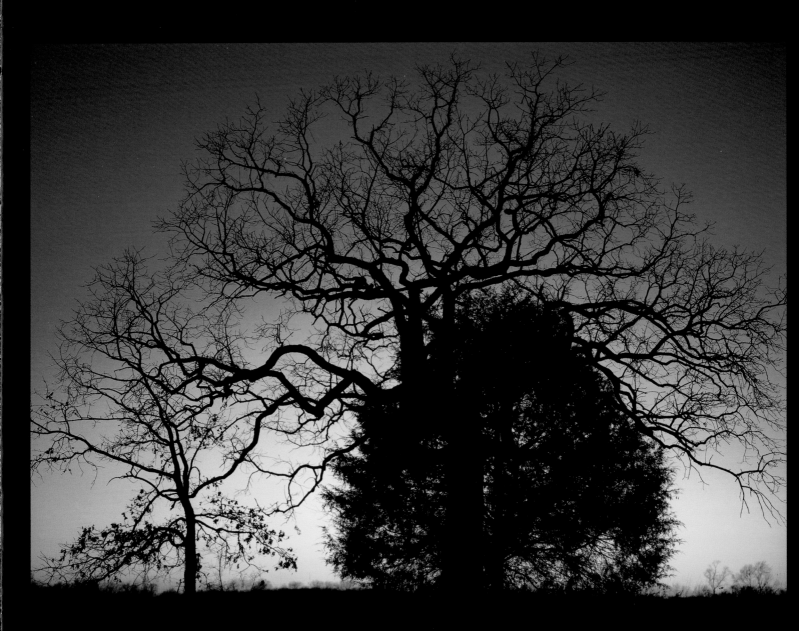

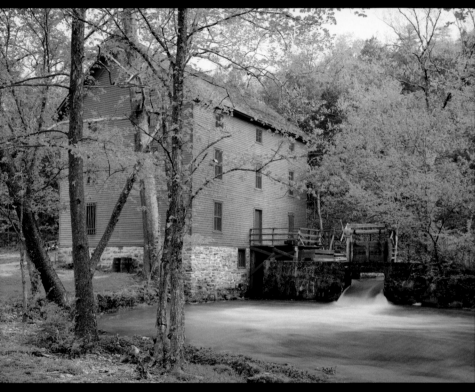

Print and Book Ordering Information

FOR MORE INFORMATION CONTACT:

KEVIN SINK PHOTOGRAPHY
4904 MOHAWK DRIVE
SHAWNEE MISSION, KS 66205-1541
(913) 384-6307

IF CALLING FROM OUTSIDE THE
KANSAS CITY AREA: 1-800-262-2749

OR VISIT OUR WEB SITE AT:
designsfromnature.com

*T*he images in this book are available as original, signed limited edition photographs in standard sizes ranging from 8 x 10" to 30 x 38" and larger. The large original film size (4 x 5") yields incredibly sharp prints with vivid colors even in very large sizes.

This book is also available in a limited collectors edition which includes a decorative slipcase, a signed and numbered page of authenticity, and comes with a 16 x 20" print of the cover photograph, available only with the purchase of the limited edition version of the book.

ALLEY SPRING, OZARK NATIONAL SCENIC RIVERWAYS, SHANNON COUNTY

Bibliography

Brown, Joseph Epes. *The Sacred Pipe.* Norman, OK: University of Oklahoma Press, 1953

Brown, Joseph Epes. *The Spiritual Legacy of the American Indian.* New York, NY:
The Crossroads Publishing Co., 1993

Campbell, Joseph; with Moyers, Bill. *The Power of Myth.* New York, NY: Doubleday, 1988

Einstein, Albert. *Ideas and Opinions.* New York, NY: The Modern Library, 1994

Fonteyn, Margot. *Margot Fonteyn Autobiography.* New York, NY:
Alfred A. Knopf, Inc., 1976

Gale's Quotations. (CD ROM) Detroit, MI: Gale Research Inc., 1995

Hammarskjold, Dag. *Markings. New York, NY: Alfred A. Knopf, 1964*

Kavanaugh, James. *There are Men Too Gentle to Live Among Wolves.* Highland Park, IL:
Steven Nash Publishing, 1990

Lawrence, D. H. *The Complete Poems of D. H. Lawrence.* New York, NY:
Penguin Putnam, Inc., 1971

Leopold, Aldo. *A Sand County Almanac.* New York, NY: Oxford University Press, 1966

McLuhan, T.C.. *Touch the Earth: A Self Portrait of Indian Existence.* New York, NY:
Outerbridge & Dienstfrey, 1971

Schaefer, John. *An Ansel Adams Guide: Basic Techniques of Photography.* Boston, MA:
Little, Brown & Co., 1992

Terres, John K.. *Things Precious and Wild: A Book of Nature Quotations.* Golden, CO:
Fulcrum Publishing, 1991